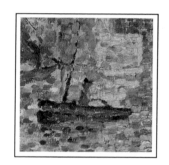

THE ART OF THE
POST-
IMPRESSIONISTS

Edmund Swinglehurst

A Compilation of Works from the
BRIDGEMAN ART LIBRARY

SIENA

Post-Impressionists

This edition first published in 1995 by
Parragon Book Service Ltd
Units 13-17 Avonbridge Industrial Estate
Atlantic Road
Avonmouth
Bristol BS11 9QD

ISBN 0 75251 100 9

Printed in Italy

Editors: Barbara Horn, Alexa Stace, Alison Stace, Tucker Slingsby Ltd and
Jennifer Warner.
Designers: Robert Mathias and Helen Mathias
Picture Research: Kathy Lockley

The publishers would like to thank Joanna Hartley at the
Bridgeman Art Library for her invaluable help.

POST-IMPRESSIONISTS

THE TERM POST-IMPRESSIONISM was invented by Roger Fry, the English art critic, when he organized in London in 1910 an exhibition of work by painters for whom Impressionism had opened up new windows on art but who rejected the Impressionist theories as a standard technique for painting. Inevitably, the term covers a wide field of activity, just as Impressionism does, and does not imply any particular style or technique. Post-Impressionism is not a coherent idea, but covers the work of many painters of the generation who came after the Impressionist period, and whose unifying idea might be said to be that they were all looking for a more formal solution to their painting problems. They were reacting, mainly, against the style of Claude Monet.

Within the period of Post-Impressionism there were many small groups of artists who acquired soubriquets, even nicknames for their work style at a given period. For many, the style was merely a phase through which they were passing on the way to the final definition of their personalities as painters.

The first logical extension of Impressionism was devised by the Pointillists, or Divisionists as their leader, Georges Seurat, preferred their theory to be called. The Divisionist theory was that the short brush strokes used by the Impressionists should be reduced to uniform dots, each of a primary colour which, when placed alongside another primary colour, would produce the complementary colour in the viewer's eye. For example, a yellow dot and a blue dot would produce the effect of green. The idea seemed very rational and it attracted a number of painters, including Signac, Cross and Camoin.

A more interesting and influential group was that of Paul Gauguin

and his friends at Pont-Aven in Brittany. Gauguin, who had been a friend of Van Gogh and worked closely with him for a time, though he disagreed with the latter's method of putting paint on canvas, had been influenced by Japanese art and was intent on using in his paintings the spacious composition and flat colour of Japanese prints. Gauguin, who had been a merchant seaman and a stockbroker, took up painting in his late twenties. He dabbled in Pointillism but then rapidly developed his own style which came to be called Synthetism; it was followed by Paul Sérusier and Emile Bernard at Pont-Aven but also influenced a wider circle.

An easily identifiable style in the Post-Impressionist period was Fauvism. The Fauves, or wild animals, as they were called at their exhibition in Paris in 1905, included Matisse, Picasso, Derain, Vlaminck, Rouault, Marquet and even that most sober of still life painters, Georges Braque. The name Fauve was given to them because they had decided to carry colour to its limits by using it pure, as Van Gogh had done, and transposing it in an arbitrary fashion, for example, painting skies yellow and seas pink etc. The theory was that colour could have other values than the conventional one without destroying the credibility of a painting. Fauvism was short-lived, but it gave a healthy shake-up to current theories about colour.

Another distinctive style was that of Pierre Bonnard and his followers Vuillard and Denis. Bonnard and his friends used colour with the same freedom as the Fauves, but allowed the shape and size of the forms to be dictated by the value of each colour. In this, they were forerunners of Matisse and were also like him in their love of domestic subjects and decorative effects.

The most potent of all the artistic ideas that arose in the Post-Impressionist period was Cubism. This theory emerged from the art of Cézanne, one of the most unsuccessful of artists in his lifetime but the most powerful influence subsequently. Cézanne was interested in studying the structure of the outside world and expressing it in planes of colour. This idea, which was related to current scientific absorption in defining the structure of the universe through the Atomic theory,

was taken up by Picasso. He combined it with his interest in African art to produce the Cubist idea which influenced practically all subsequent art, both fine and commercial. Cubism had many adherents including Braque, Gris and Delaunay.

Among the Post-Impressionist artists there were those who experimented with the new ideas and moved on to greater and more original work; and there were those who remained within the style and techniques of their particular group. Among the originals were Picasso, Matisse and also Mondrian, creator of abstract art. Each of these three had a new and original vision which has influenced artistic thinking to the present day.

In this book, those artists who belonged to or were influenced by specific trends have been grouped together; in some cases, they can be put into a chronological order, but others, part of a particular theory or group of artists, may be contemporaneous with another and thus cannot be fitted into a historical progression. Grouping artists together will, it is hoped, make the story of Post-Impressionist art appear more coherent to the reader.

▷ **Mont Ste Victoire** 1880-85
Paul Cézanne (1839-1906)

Oil on canvas

ALTHOUGH HE WAS a contemporary of leading Impressionists, including Monet, Renoir and Sisley, Cézanne did not share their views on painting. After a start with a romantic style influenced by Delacroix, Cézanne turned to a more structured view of nature. Mont Sainte Victoire, near his home in Aix-en-Provence, became a feature of the landscape which obsessed him more than any other. The mountain, and the still-lifes which he set up in his studio, became the means through which he created a new painter's vision which was to be the major inspiration for the art of the 20th century. Cézanne was not so much rebelling against Impressionism by devising a new technique as re-working it in the classical tradition of Poussin. He developed a slow, painstaking technique in which every plane of colour was carefully placed and the colour itself was chosen deliberately to give a sense of its position in the space of the picture. As he himself put it, 'When colour had its richness form has its fullness.'

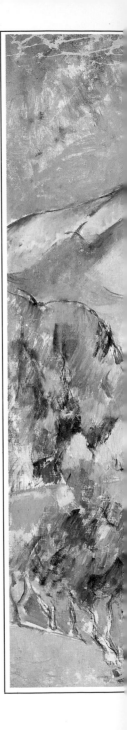

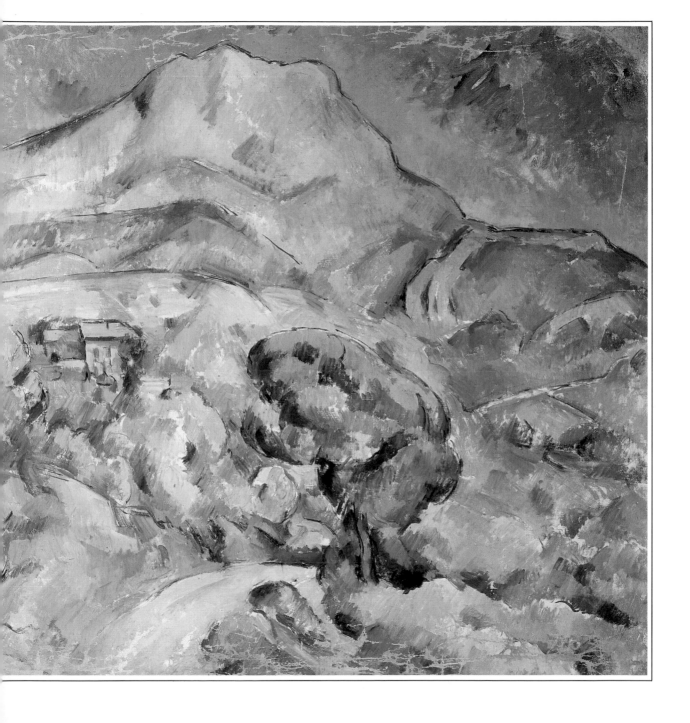

▷ **The Sister's Pool, Osny** c1875
Paul Cézanne (1839-1906)

Oil on canvas

OUT OF THE CONFUSION of trees and green foliage before him, Cézanne has cleared a well-ordered and structured world of a pool among trees. At a time when many painters depicted trees as spongy brown backgrounds, Cézanne's approach was revolutionary. Although his approach was the result of the intellectual contemplation of a painter's problem, Cézanne never lost his passion for the objects he painted, whether they were trees or apples, and this saves his work from being a cold, cerebral excercise. By nature, Cézanne was a man with powerful feelings, as one can see in his earlier work, but he learned that emotional power is even greater when curbed and disciplined than when allowed to run riot.

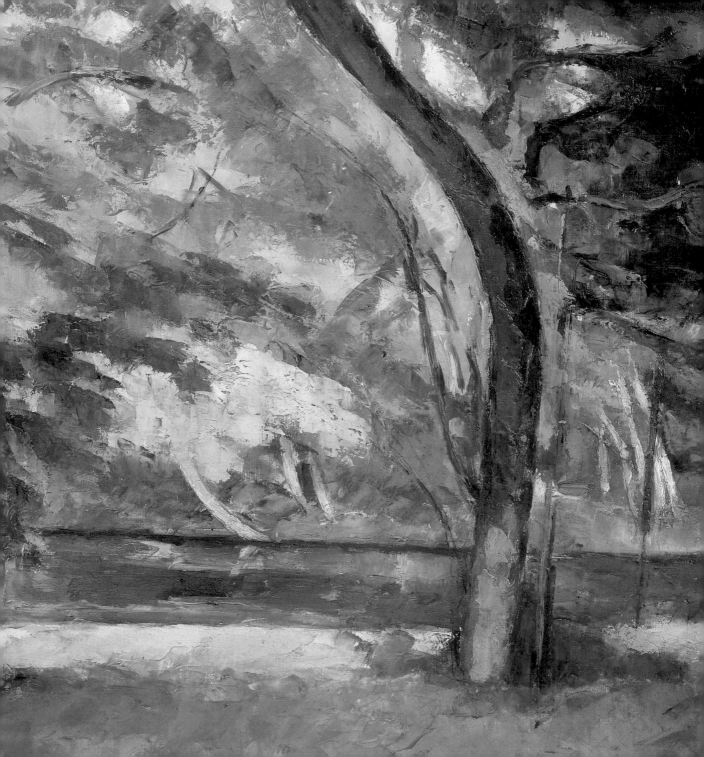

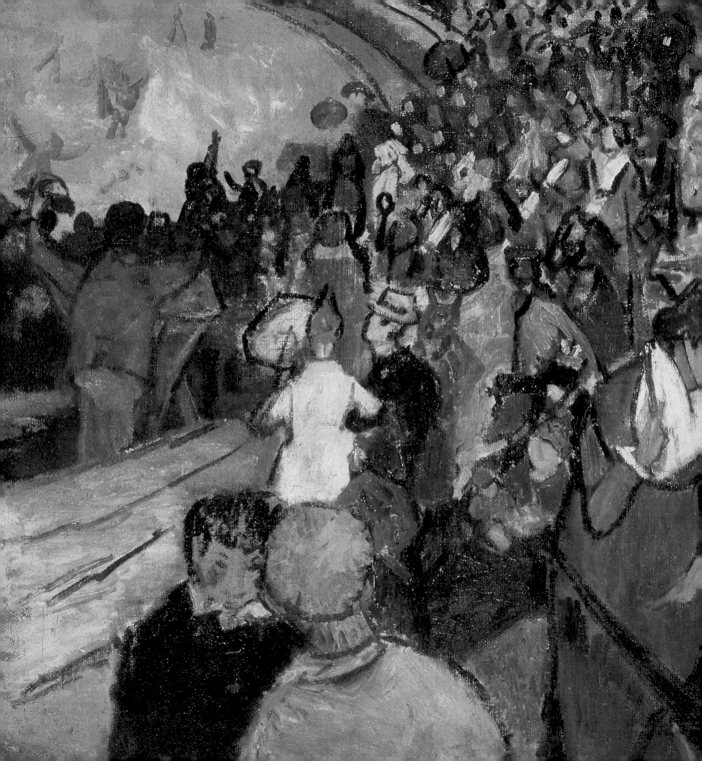

◁ **The Arena** 1888
Vincent van Gogh (1853-90)

Oil on canvas

WHEN VAN GOGH first came to Paris to join his brother Theo, an art dealer, he was sufficiently impressed with the work of the Impressionists to give his own paintings a lighter, more colourful appearance. He was too much of an original to remain an Impressionist for long, however, and when he set up his studio in Arles he began to work in a rapid and confident manner, using bold streaks of primary colours with vibrant brushstrokes. His compositions, influenced by Japanese prints, at first shocked everyone. Later, they came to be seen by other artists as a means of liberating colour and led to the experiments of the Fauves and to new attitudes to theories of colour. In *The Arena at Arles*, one of van Gogh's first Provence paintings, he was already trying to use flat areas of colour instead of the short brushstrokes of the Impressionists, and was, in fact, leading the way out of what had become a convention.

▷ **The Starry Night** 1889
Vincent van Gogh (1853-90)

Oil on canvas

THIS IS ONE OF THE MOST powerful of van Gogh's night pictures, conveying in strong terms his feelings about the deep rhythms of the universe that govern human life. Here, the earth and the sky are a cosmic unit caught up in irresistible forces. Van Gogh himself felt that he was an instrument of a power greater than himself and in the last years of his life sensed a need to work ceaselessly to record the life that surrounded him. This painting was made at St-Remy-de-Provence after the mental crisis at Arles which had led him to cut off part of his ear. He had taken refuge at the lunatic asylum of St Remy in order to try to regain his composure. The freedom of his brushwork and the audacious use of colour in his work in Provence had a considerable influence on other painters after his death.

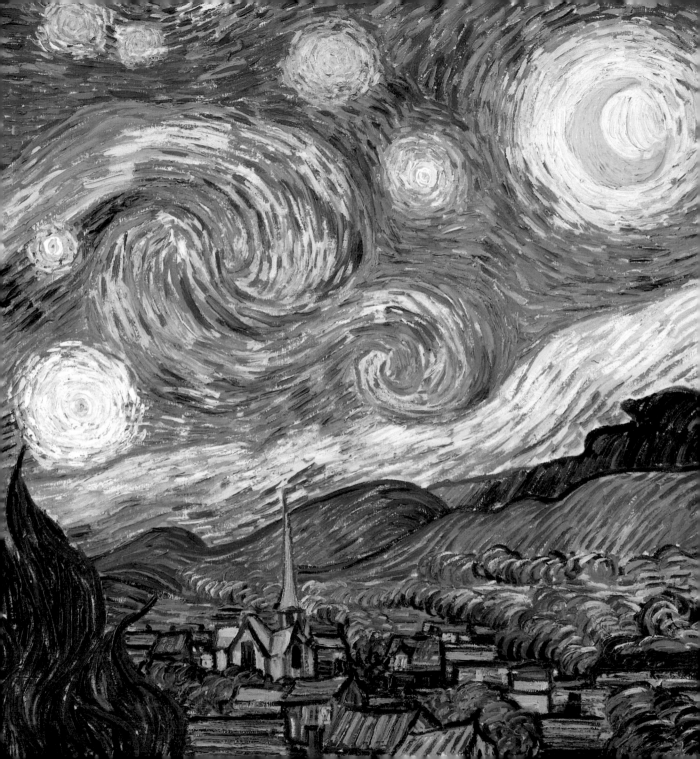

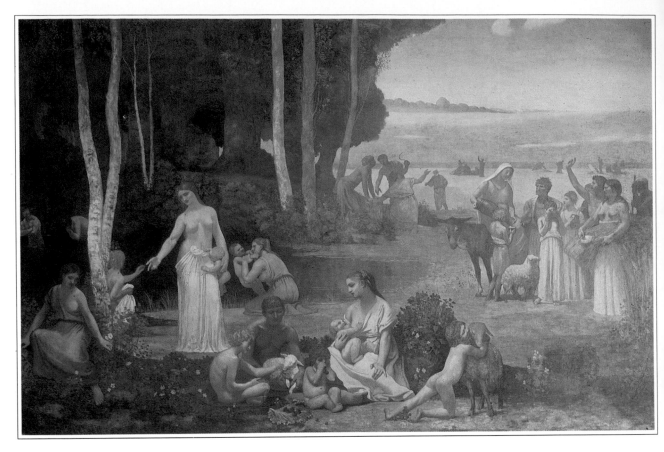

△ **Summer** 1884
Puvis de Chavannes (1824-98)

Tempera

PUVIS DE CHAVANNES'S life spanned the Impressionist and Post-Impressionist periods and, although he was unaffected by either, his work was much admired by the Post-Impressionists. They approved of his broad flat treatment of paint, a style which had sprung from the study of Japanese prints. Chavannes's work also appealed because of the symbolic character of his paintings in which he was trying to evoke the grand Italian fresco style. His symbolism made his work acceptable to Symbolist painters like Gauguin, and also to official bodies who commissioned him to decorate town halls, like the Hotel de Ville in Paris, and other public buildings.

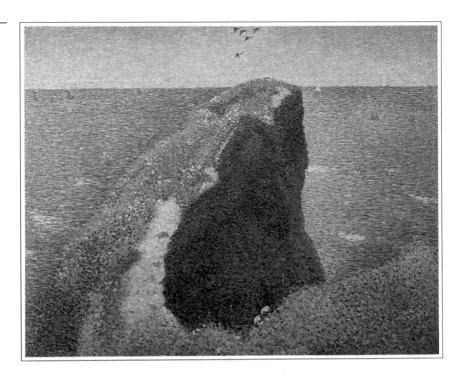

△ **The Bec du Hoc** 1884
Georges Seurat (1859-91)

Oil on canvas

IT WAS ALMOST INEVITABLE that the theories of Impressionism, making as they did a complete break from dark brown salon art, should lead to new ideas. The Neo-Impressionists, led by Seurat, theorized that if complementary colours were separated into their components and these were placed alongside each other, a livelier mix would take place in the viewer's eye. The method he used was called Pointillism by the general public but Divisionism by Seurat. In this landscape of the Bec du Hoc in northern France, Seurat has established a careful drawing for his Divisionist colours, creating a solid classical composition which, neverthless, lacks the spontaneity of the paintings of the same area by the great Impressionist, Claude Monet.

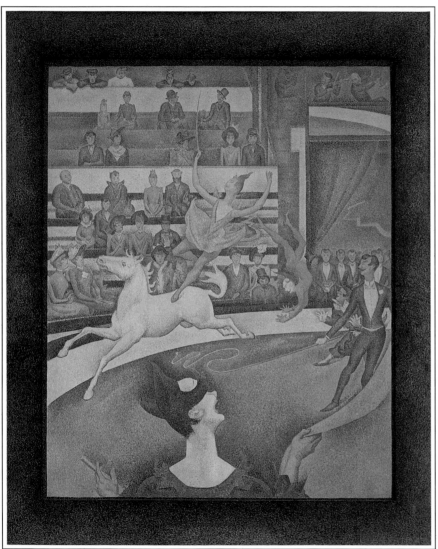

◁ **The Circus** 1891
Georges Seurat

Oil on canvas

SEURAT'S INTEREST in people, which blossomed in such paintings as *Sunday Afternoon at the Grand Jatte* and *Bathing at Asnières*, showed ordinary people at leisure on the banks of the Seine. This interest later spread to other places of entertainment, like café concerts and the circus. The Cirque Medrano was a popular place patronized by artists as well as the general public, providing inspiration for Degas and Renoir, among others. Seurat treated the subject in a very different way from the latter, however, eliminating the romantic atmosphere and increasing the traditional qualities of composition and drawing. He also applied colour in his Divisionist style. But this technique never attained the brilliance of colour achieved by Impressionism.

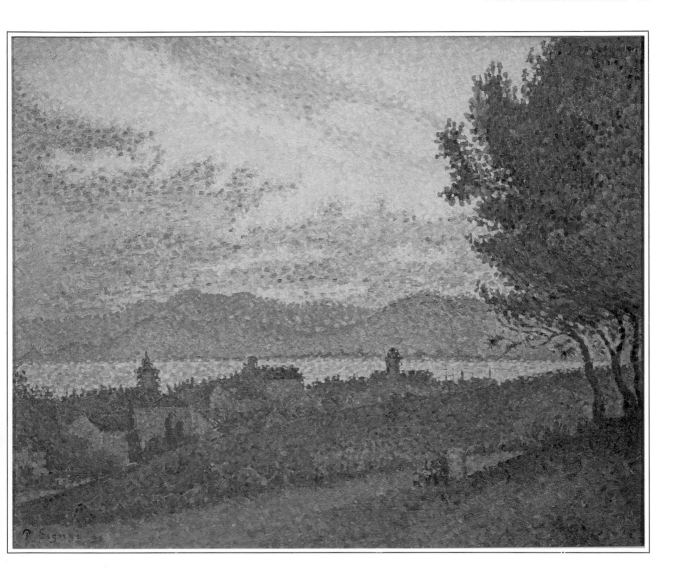

St Tropez Pinewood 1890
Paul Signac (1863-1935)

◁ *Previous page 19*

Oil on canvas

PAUL SIGNAC was Seurat's most ardent admirer and follower, even writing a book, *From Delacroix to Neo-Impressionism,* which explained Divisionism as the logical progression of Impressionism. A prolific painter who much admired the work of J.M.W. Turner, Signac spent much of his time at St Tropez, a small fishing port on the south coast of France where the Divisionist painters gathered before the age of tourism. In this picture, called *St Tropez Pinewood* though only one tree is visible, Signac has painted the view over the St Tropez rooftops looking across the bay to St Maxime, with the pink granite mountains of the Esterel beyond.

▷ **The Port at La Rochelle** 1924
Paul Signac (1863-1935)

Oil on canvas

LA ROCHELLE is an important seaport on the Atlantic coast of France which has attracted many artists and writers. In this painting Signac has chosen as his subject the entrance to the port, guarded by its two towers, and shows a fishing smack entering the inner harbour. The predominantly blue tone of the painting surrounds a warm centre of pink clouds and brown sails, creating a vortex repeated in the waters of the foreground. As in most Divisionist paintings, the dots of both warm and cold colours appear all over the painting in varying intensities. This approach created a certain repetitiveness in the Divisionist style, which drove many who approved of the logic of Divisionism into other fields of experiment.

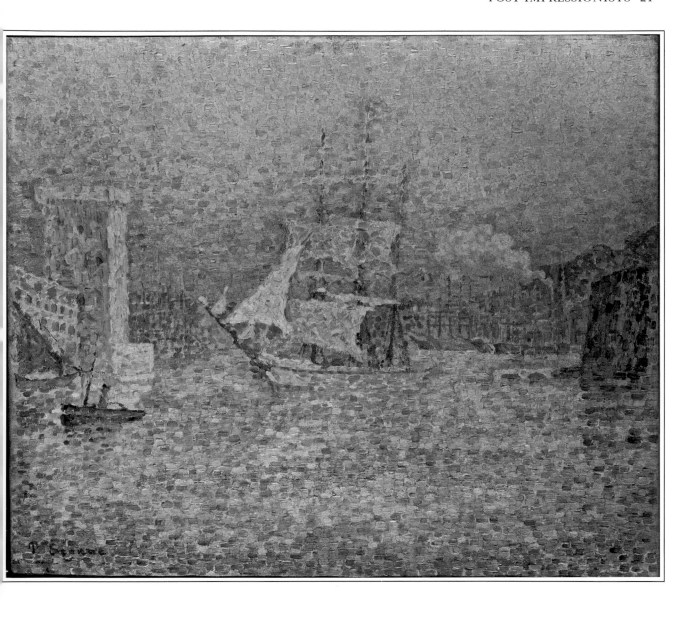

▷ **Village by the Sea** 1905
Charles Camoin (1879-1965)
© ADAGP, Paris and DACS, London 1995

Oil on canvas

THIS PAINTING OF a harbour at Collioure, a fishing port near the Mediterranean border of France and Spain, was made after Camoin had ceased to experiment with Divisionism. It shows a breakaway from the Impressionist technique of small brushstrokes and the use of flatter areas of colour.

Camoin became a follower of Seurat and joined his circle at St Tropez, which had become popular among artists and writers after visits by Guy de Maupassant and Colette. Camoin later retreated from this style of painting, as did Pissarro, who had experimented with it late in life.

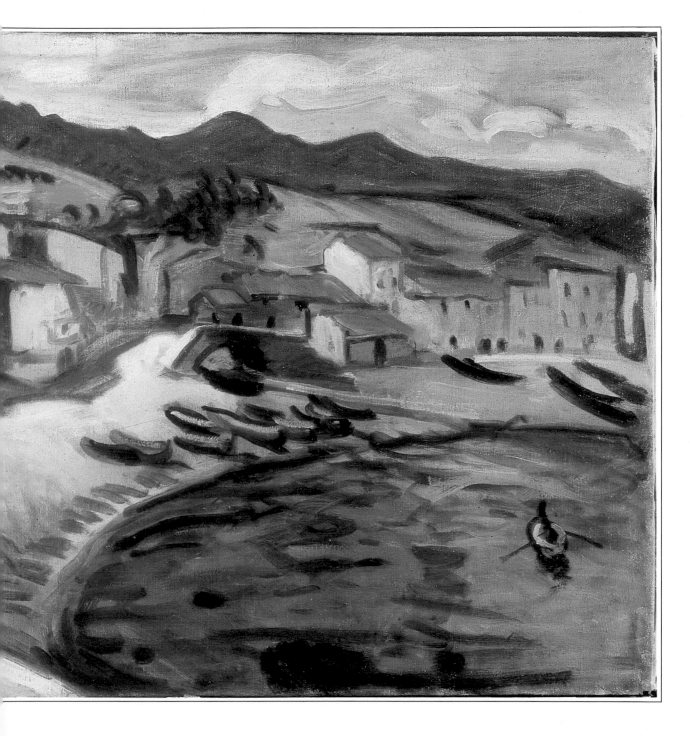

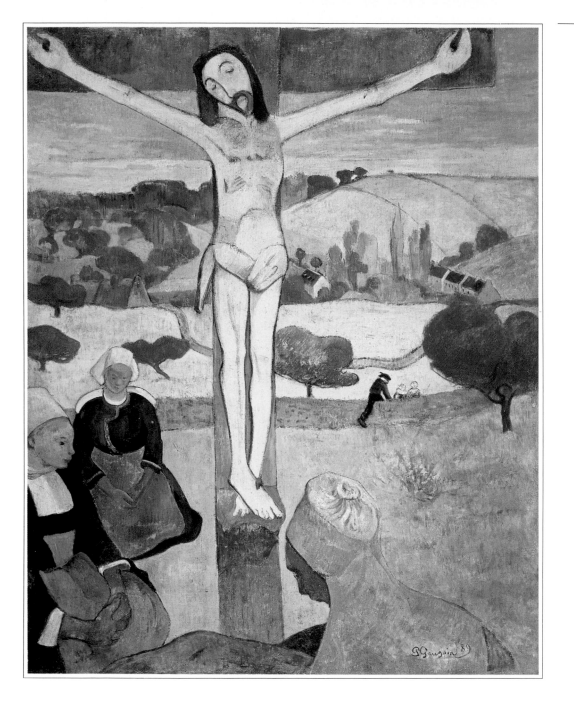

◁ **Yellow Christ** 1889
Paul Gauguin (1848-1903)

Oil on canvas

PAUL GAUGUIN was an individualist. He became a painter when he was nearly 30 after careers as a merchant seaman and a stockbroker. He followed the Impressionists for a while but soon broke away to follow his own ideas in Pont-Aven in Brittany. Influenced by Japanese and medieval French art, he developed a style with flat colour and broad shapes with little modelling. This painting, *Yellow Christ*, shows that his own technique had matured during his stay in Brittany and the strong flat yellow of Christ's body makes an impressive effect.

Christ in the Garden of Olives 1889
Paul Gauguin

▷ *Overleaf pages 26-7*

Oil on canvas

BEFORE HE LEFT for Tahiti in 1891 Gauguin had already advanced considerably in creating his own style of painting. His forms were not yet as simple and 'primitive' as they were to become later, and he had not yet overcome the Impressionist manner of applying paint in short brushstrokes, but there is a breadth in this painting that sets it apart from other painters of the time. The crystallization of his ideas on painting had led to many heated discussions with van Gogh when they were sharing a studio in Arles in 1888. The tension between the artists culminated in van Gogh's cutting off part of his ear and leaving it for one of the prostitutes at a local brothel.

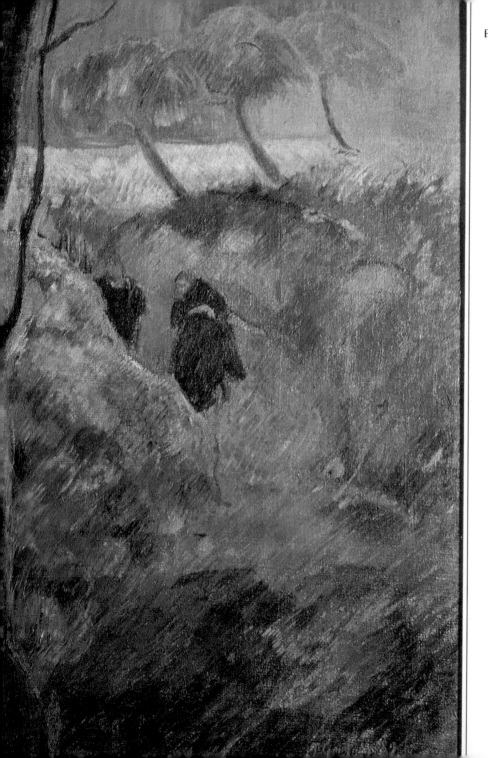

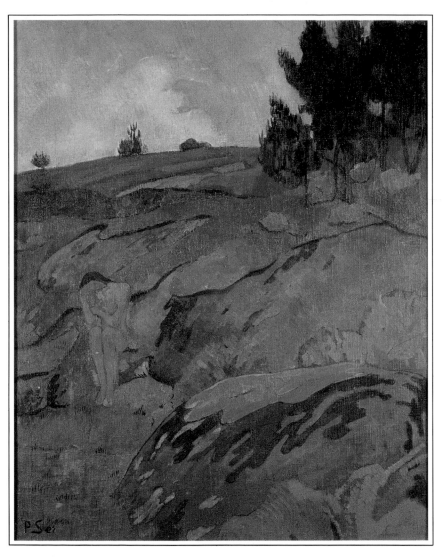

◁ **Melancholia** 1890
Paul Serusier (1864-1927)

Oil on canvas

GAUGUIN, who was a strong personality, gathered other painters around him at Pont-Aven as he struggled to develop his ideas on technique. Serusier was attracted by Gauguin's uncompromising attitude to the use of pure colour – a tendency he shared with van Gogh. Later, Serusier found himself more in sympathy with the group known as the Nabis and he gave up the formal approach of Gauguin's Synthetism for the freer style of Bonnard's painting. Serusier published his own ideas on painting in *Le ABC de la Peinture* in 1921. In this rather sombre painting, the influence of Gauguin is evident, though there is also a hint of the Serusier who later took up religious art at a German monastery.

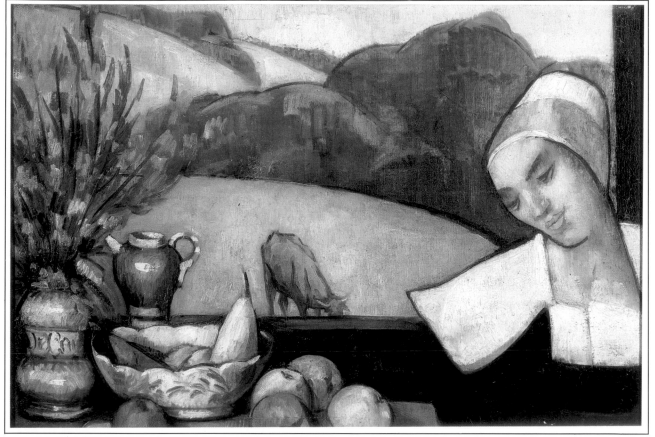

△ **Pont-Aven** 1888 Emile Bernard (1868-1941)
© DACS 1995

Oil on canvas

AFTER EXPLORING THE THEORY of Divisionism with Seurat, Emile Bernard broke away from what seemed to him too rational and systematic an approach to art. Having destroyed all his work, he joined Gauguin at Pont-Aven in 1886 and began to evolve his own version of the flat brushwork and broad forms used by Gauguin. This style came to be known as *cloisonné*, after the technique used in enamelware. When Gauguin began to receive the credit for Bernard's work, the latter became annoyed and left Pont-Aven. In the end, however, his own inspiration began to flag and his work became sentimental in tone. This painting done while Bernard was still with Gauguin, has formal strength and the colours, though subdued, are significant.

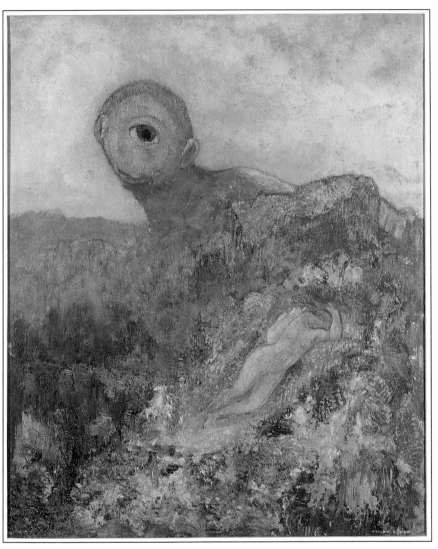

◁ **The Cyclops** 1898
Odilon Redon (1840-1916)

Oil on canvas

WHEN HE WAS NOT painting in a straightforward Impressionist style Odilon Redon was an original and visionary painter who painted imaginative fantasies: according to Redon himself, the fantasies were simply another version of reality. It was the fanciful part of his work which gained him fame in Paris after 1879, when he was acclaimed as the leading Symbolist painter. Like his friend the poet Mallarmé, who was also a friend of the Impressionists, Redon thought that life was full of ambiguities and that there was no one explanation for it. In later life Redon underwent a spiritual crisis, like Mallarmé himself, and committed suicide in 1916. In *The Cyclops* he shows the one-eyed giant peering over a bank of flowers at a naked woman. Eyes were a part of the anatomy that obsessed Redon, who imagined that God must have experimented with the centre of flowers before creating eyes.

▷ **The Bridge at Aasgaardstrand** 1900
Edvard Munch (1863-1944)
© THE MUNCH MUSEUM/
THE MUNCH-ELLINGSEN
GROUP/DACS 1995

Oil on canvas

AMONG THE MANY artistic styles that followed Impressionism was Expressionism – the attempt by an artist to put down feelings directly without the modifying influence that time and thought give to emotional crises. It has been said that one of the first Expressionists was, in fact, the medieval artist Grunewald, whose bleeding, lacerated Christ has echoes of the tortured statuary of Catholic churches. Norwegian-born Edvard Munch spent some time in Paris and Germany and came to feel that truth lay in the direct expression of emotions. Munch added a personal neuroticism to his work – his exhibition in Berlin in 1892 influenced German painters, making Munch a forerunner of Expressionism. In this picture there is the same sense of isolation and loneliness expressed in his famous painting, *The Scream*.

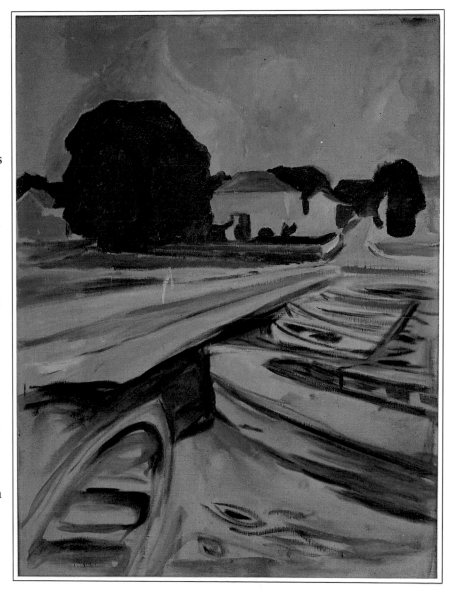

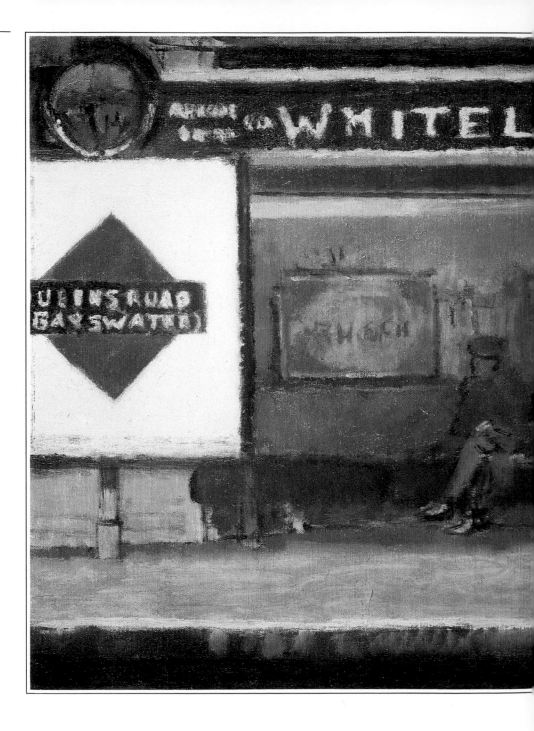

◁ **Queen's Road Station, Bayswater** c1916
Walter Richard Sickert (1860-1942)

Oil on canvas

THE CAMDEN GROUP of painters took their name from the part of London where Walter Sickert had his studio. This rather seedy area with its faded music hall appealed to Sickert, an individual artist whose paintings were outside the conventions of the Royal Academy. Though often called an Impressionist, Sickert's work was usually sombre in tone and the paint, though applied freely, was not in the broken brushstrokes of Impressionist painters like Monet. In this painting of a tube station platform in London, Sickert has shown his liking for ordinary subjects relevant to the life of ordinary people; in this he has a certain affinity with painters like Degas and Toulouse-Lautrec.

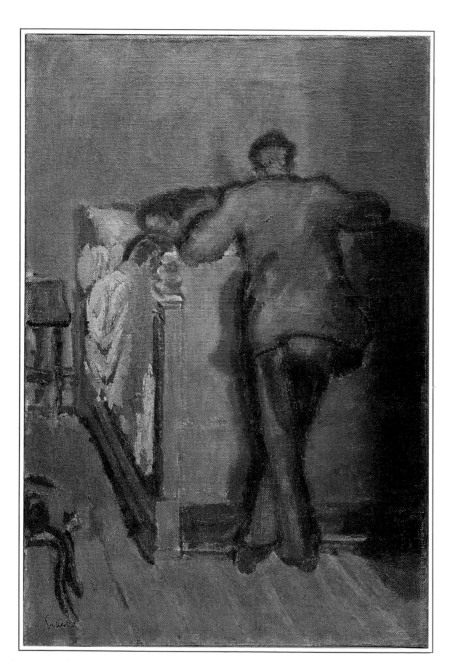

◁ **The Bedroom** 1910-17
Walter Richard Sickert
(1860-1942)

Oil on canvas

SICKERT LIKED TO PAINT
domestic interiors, though he
gave them an unusual and
sometimes sinister
atmosphere. Unlike the
Impressionists, who expressed
the *joie de vivre* of the new
bourgeoisie in many of their
paintings, Sickert liked to
portray the sombre and sleazy
side of life. One set of
paintings of a man and woman
in a bedroom, probably a
prostitution scene, he chose to
title *The Camden Town Murders*,
after a series of crimes that
had taken place in this quarter
of north London. In this
bedroom painting, the
meaning is ambiguous,
perhaps in deference to British
sensibility of the time. One
cannot help feeling that if the
woman in bed was a prostitute,
a painter like Toulouse-
Lautrec would have made this
clear. The flat colour and black
outlines are reminiscent of the
French artist.

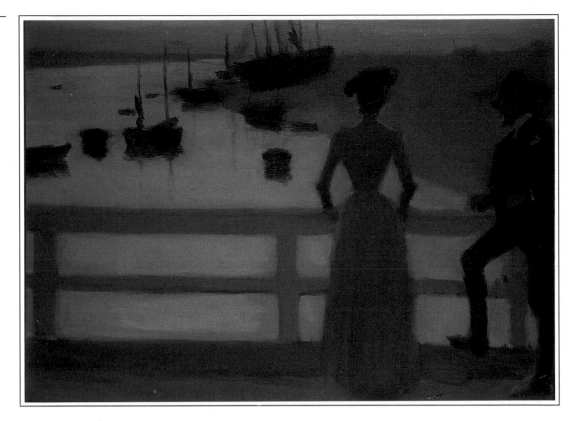

△ **The Bridge, Etaples** 1887
Philip Wilson Steer (1860-1942)

Oil on canvas

THOUGH IT WAS an English artist, John Constable, who opened the way to Impressionism and open-air painting, his innovation was not taken up in England and later English painters had to go to Paris to absorb the ideas which would change the old, conventional ways of painting. Phiiip Wilson Steer studied in Paris in 1882-3, where, as well as picking up some of the new techniques, he seems to have acquired some of the Gallic *joie de vivre* which is lacking in the work of his compatriot, Sickert. In this painting of the bridge between fashionable Le Touquet and the fishing port of Etaples, Steer has created an atmospheric effect reminiscent of early Monet and of Whistler. Later, after his return to England, his work lost some of this romantic atmosphere.

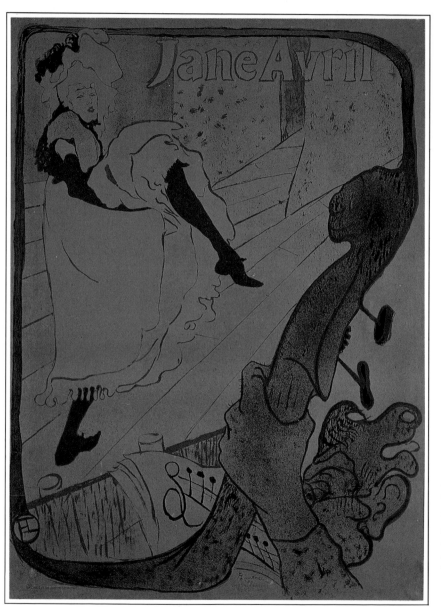

◁ **Jardin de Paris, Jeanne Avril** 1893
Henri de Toulouse-Lautrec
(1864-1901)

Lithograph

SON OF A NOBLE FAMILY from Albi, Henri de Toulouse-Lautrec broke both legs in childhood and remained a stunted cripple. He went to Paris in 1882 and soon showed an extraordinary talent for drawing, exhibiting at the Salon des Independants from 1889 onwards. He was attracted to the low life of the Ville Lumière and spent much of his time in dance-halls and brothels. His vigorous draughtsmanship enlivened scores of posters which attracted the eyes of Parisians and played their part in the wider acceptance of the new art of his time, though he was too much of an individualist to have the label of any one artistic group hung on his work. Soon after painting the dancer Jeanne Avril, he succumbed to alcoholism and was obliged to return home to be cared for by his family.

▷ **Woman with a Dog** 1891
Pierre Bonnard (1867-1947)
© ADAGP/SPADEM, Paris and
DACS, London 1995

Oil on canvas

ALTHOUGH HE WAS AWARE of the
Impressionist technique and of
Japanese prints, Pierre
Bonnard did not begin his
exploration of the world of
colour until he was entering
middle age. He took up
painting in his early 20s, and
shared a studio with Maurice
Denis and Edouard Vuillard.
Until then, his paintings had
been sombre in colour but he
now began to use more colour
with greater intensity and
developed the personal style
for which he became famous.
The studio which he shared
with his friends was the
meeting place for a group of
painters called the Nabis – the
prophets – who followed
Gauguin's flat colour painting
style and whose aims were
expressed by Denis as the
covering of a flat surface with
colours assembled in a certain
order. The aim was, therefore,
largely decorative, though
Bonnard imbued his paintings
with the atmosphere of his
home and garden, the main
subjects of his work.

▷ **In Summer** 1931
Pierre Bonnard
© ADAGP/SPADEM, Paris and DACS, London 1995

Oil on canvas

THIS PAINTING IS A VIEW over Bonnard's garden at Le Cannet, looking down over distant Cannes. Once he had settled in the south of France, Bonnard did not move far from his home, finding plenty to paint in his own domestic kingdom. His wife, Marthe, posed for him while doing household chores or entering or leaving her bath. Like Monet at Giverny, Bonnard was pursuing an idea rather than trying to record different places. His exploration of colour became more and more audacious and his flat patches of bright colour swam freely over his canvas but always in that certain order that Denis had insisted on in his explanation of the Nabis's aims. In this painting, the light touch and unformalized drawing give a sense of space and atmosphere through the colour alone.

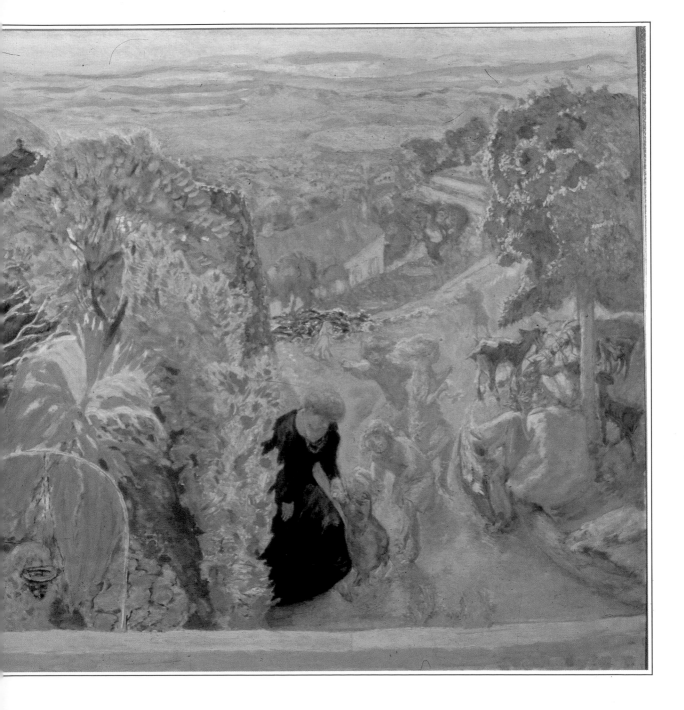

▷ **Interior with Mme Vuillard** c1900
Edouard Vuillard (1868-1940)
© DACS 1995

Oil on canvas

EDOUARD VUILLARD, though he shared a studio with Pierre Bonnard, did not entirely follow in his footsteps but remained closer to the subject of his paintings, which were domestic or landscapes. He was also a painter-decorator; for patrons like the Natansons, Prince Bibesco and the Bernheims, he produced many large paintings suitable, like tapestries, for hanging on walls. In this painting showing his wife and, possibly, himself in the right foreground, he has given the whole canvas a red tone and used this as a foil for cooler colours, especially in the area of the table and lamp.

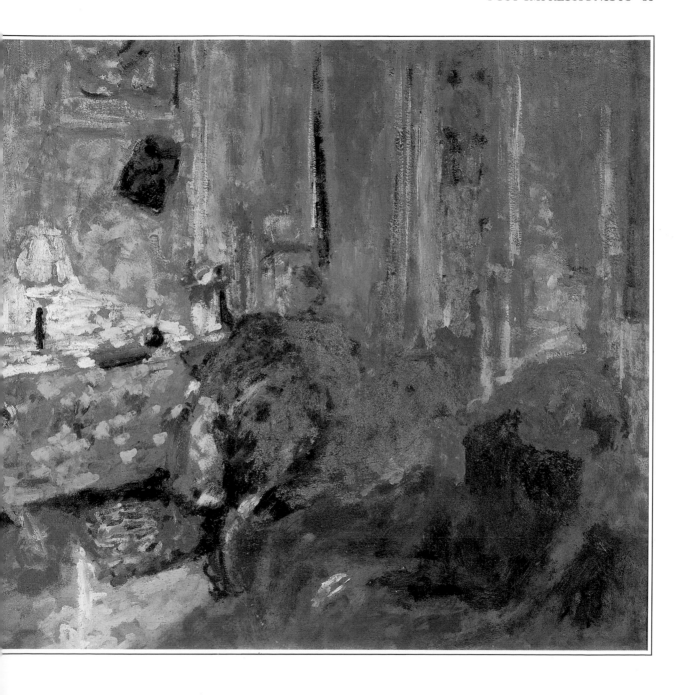

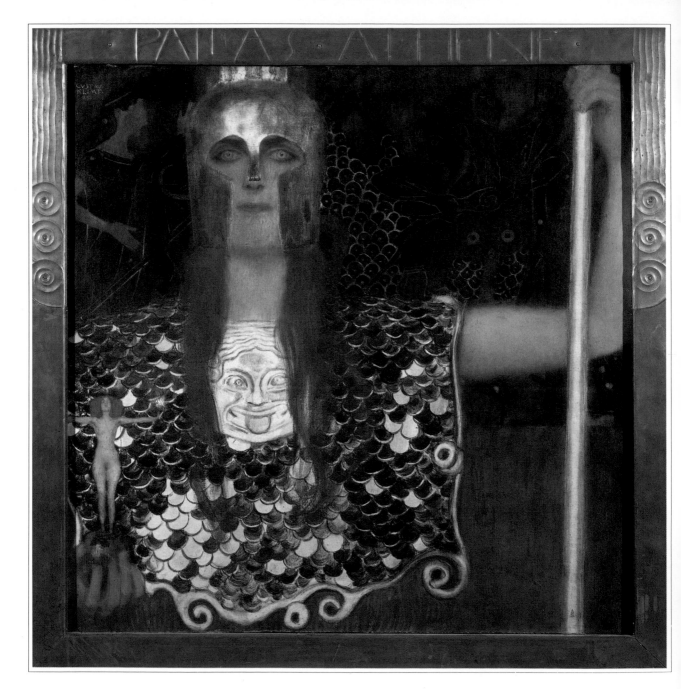

◁ **Pallas Athene** 1898
Gustav Klimt (1862-1918)

Oil on canvas

GUSTAV KLIMT was an Austrian artist whose work felt the impact of Japanese prints and of the British Pre-Raphaelites, with their meticulous painting of detail, especially in the decorative areas of their paintings. The decorative element in Klimt's work made him Austria's foremost art nouveau (*jugendstil*) painter and it also linked him with the French artists Bonnard and Vuillard, though he showed little interest in their exploration of the use of colour as a means of expression. Klimt's main success was in the applied arts, and he shared a studio with his brother while working on decorations at the Kunsthistorisches Museum in Vienna. He had some influence on the Austrian painters Schiele and Kokoschka, but was little regarded in the rest of Western Europe until relatively recently.

The Dream 1910
Henri Rousseau (Le Douanier) (1844-1910)

▷ *Overleaf pages 44-5*

Oil on canvas

POST-IMPRESSIONIST ART, with its many theories and its continuing search for inspiration, even in ethnic and children's art, opened up the public mind to accepting naïve art, such as that produced by the 'Sunday painter', Henri Rousseau. Rousseau, who worked in the Paris Municipal customs service – hence his nickname, Le Douanier – was a talented exponent of a simple approach to painting, with a brilliant and childlike imagination. This imaginative streak led him to claim that the wild animals which figured in many of his paintings came from studies made in Mexico, a country he had probably never visited. His acceptance at the Salon des Independants, where he exhibited from 1886, and a dinner given in his honour at Picasso's studio in 1908 established him firmly among Post-Impressionist artists and brought him lasting public fame.

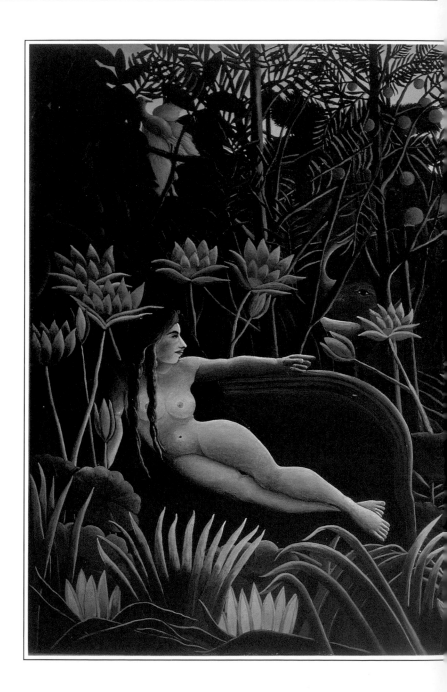

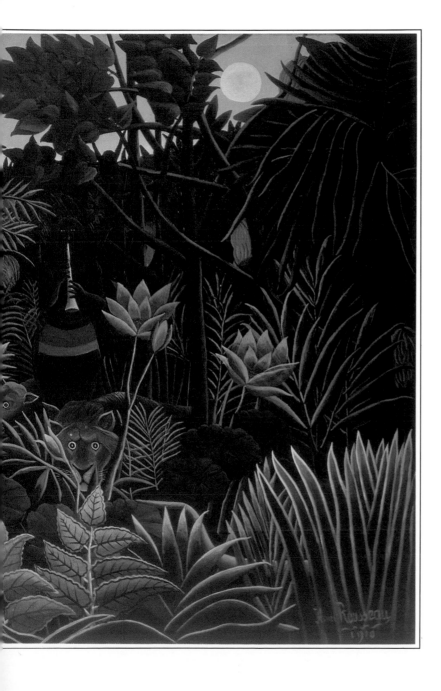

◁ **The Anglers** 1908
Henri Rousseau (Le Douanier) (1844-1910)

Oil on canvas

ROUSSEAU'S most celebrated works are exotic 'jungle' paintings such as *The Dream,* but he also produced landscapes, symbolic canvasses such as *War* (1894), commemorations of civic events, and portraits. He had a pronounced taste for group portraits in which the subjects are posed with theatrical pride, showing off their accomplishments in sublime unconsciousness of their absurdity. Long before *The Anglers,* Rousseau had painted a line of mustachioed military look-alikes in *The Artillerymen* (1893), while the more recent *Union of the People* (1907) featured a bizarre collection of diplomats, stiffly assembled to salute the French Republic; his works of this type are often reminiscent of fairground art. In an age when formal training was still assumed to be indispensable, Rousseau played a vital pioneering role, his almost simple-minded self-confidence enabling him to weather ridicule and win respect for the self-taught 'naive' artist.

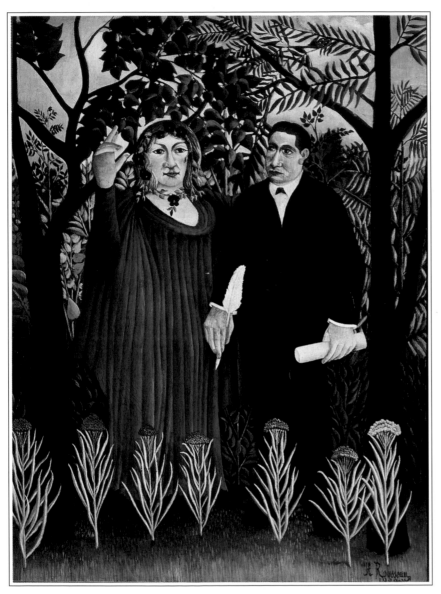

◁ **The Muse Inspiring the Poet** 1909
Henri Rousseau (Le Douanier)
(1844-1910)

Oil on canvas

DESPITE ITS PORTENTOUS symbolic title, this is a double portrait of two younger contemporaries of Rousseau: the poet Apollinaire and his mistress, the painter Marie Laurencin. The writer holds a quill and a scroll, while his muse raises her hand in benediction. Apart from his own literary work, Apollinaire was important as a propagandist for modern art, and in particular for the Cubism of Picasso and Braque. He also championed Rousseau, whom he met in about 1907, although his enthusiasm did not extend to prompt payment of the 300 francs he owed for *The Muse*. However, the poet left an amusing description of his sessions with Rousseau, who tried to keep him entertained by singing him old songs he had learned in his childhood. Rousseau painted two versions of the subject, different in a great many details; this one (in the Pushkin Museum, Moscow) is the livelier and more exotic.

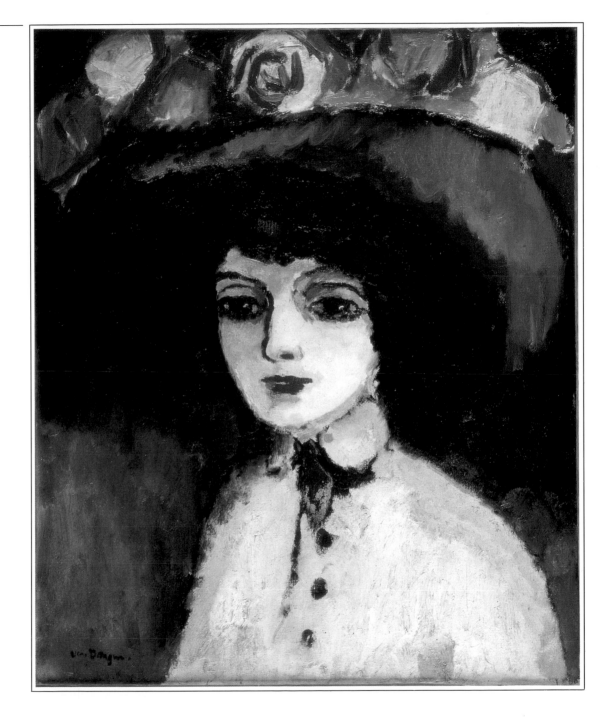

The Parisienne of Montmartre
1930
Kees Van Dongen (1877-1968)
© ADAGP, Paris and DACS,
London 1995

◁ *Previous page 49*

Oil on canvas

THE SKILL WITH which Kees
van Dongen, a Dutchman
whose artistic base for most of
his life was Paris, grasped the
idea of Fauvism and turned it
into something acceptable to
the fashionable world of the
South of France, made him
one of the best-known painters
of the *beau monde*. The high life
of the Riviera, in which he
took part, appealed to him
both as a person and as a
painter. He painted many
portraits of fashionable women
and produced designs for the
balls that were a feature of the
Summer Casino. His natural
flair for colour and design
began to deteriorate as the
years went by and his work
took on a facile and clumsy
look, as in his well-known
portrait of Brigitte Bardot.
Here, in this vivid painting of
a Parisienne, he is at the
height of his powers.

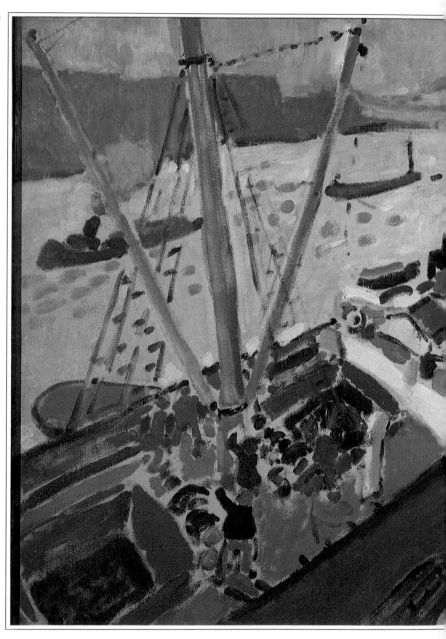

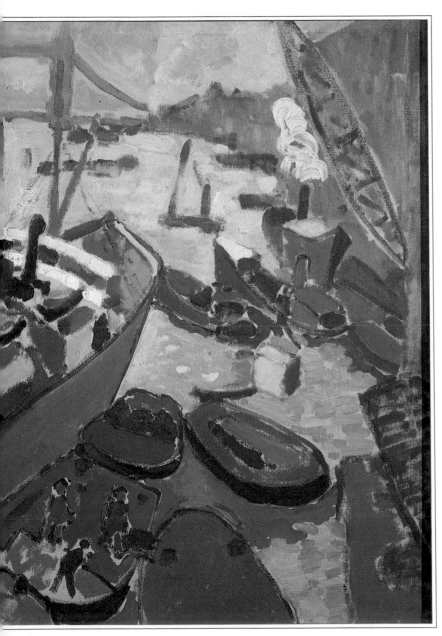

◁ **Pool of London** c1906
André Derain (1880-1954)
© ADAGP, Paris and DACS,
London 1995

Oil on canvas

ANDRÉ DERAIN was one of the most enthusiastic and successful of the Fauves, with a fine sense of control of colour and form. His early influence was Vlaminck, but his main inspiration came from Matisse himself, who persuaded Derain's parents to accept the young man's strong desire to be a painter, rather than the engineer his father had wanted him to become. Like Monet before him, Derain found inspiration in the River Thames and its shipping when he visited London in 1905, though he dealt with the subject in quite a different manner from the great Impressionist. Despite his talent for the new style of art, Derain returned to a more conventional style in the 1920s, painting in muted colours, and also achieving considerable success as a portrait painter.

▷ **Level Crossing on 14th July** 1925
Maurice de Vlaminck (1876-1958)
© ADAGP, Paris and DACS, London 1995

Oil on canvas

THIS BICYCLE RACER turned artist had the exuberant vitality of a true Fauve. Much influenced by van Gogh and African sculpture, and by Courbet, the first of the Realist artists and a man for whose Rabelasian character he felt great empathy, Maurice de Vlaminck had no inhibitions about the accepted conventions of art and launched himself into Fauvism with enthusiasm. The colour theories of the Fauves did not appeal to him as much as their freedom in the use of paint and with his natural aptitude for handling paint he soon began to produce unusual and highly personal work. In this painting of a level crossing on the 14th of July, Vlaminck uses the French flag, as many artists did, to create a festive atmosphere.

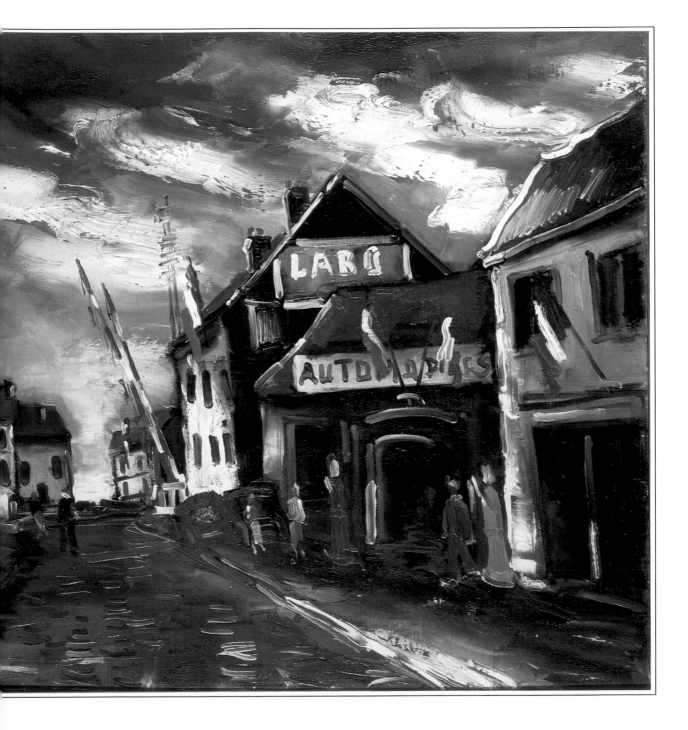

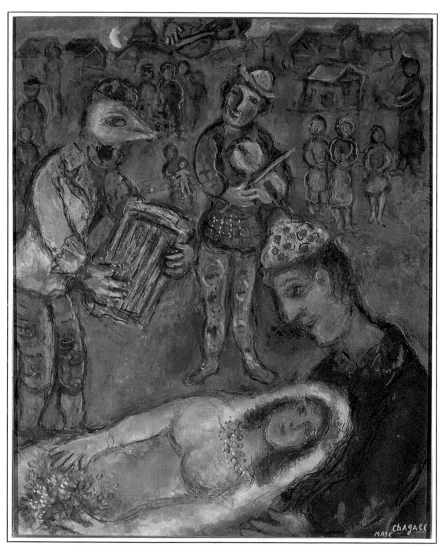

◁ **The Bride and Groom
(Les Mariés)** c1925
Marc Chagall (1887-1985)
© ADAGP, Paris and DACS,
London 1995

Oil on canvas

THE FIRST INFLUENCE on Marc
Chagall's work came from
Leon Bakst, the great theatrical
designer, and from the colour
and exoticism of the Russian
ballet, which fired the soul of
the young man from Vitebsk,
come to St Petersburg to train
as a painter. Working in Paris
between 1910 and 1914,
Chagall found himself in
another world, in which
theories about painting were
the common currency of
artists's cafés. Chagall came
into contact with Cubism, and
though he toyed with the new
theory for a while, he found it
unsuitable for the romantic
Russian part of him. The
mixture of modern art ideas
and his deeply felt Russian
character brought out the
highly original and poetic side
of his artistic character in such
works as this painting of a newly
married couple. Here, Chagall
has created a fantasy which also
has a great sense of reality,
because it is based on memories
of his youth in his homeland.

▷ **Flowers and Bird** 1952-6
Marc Chagall
© ADAGP, Paris and DACS,
London 1995

Oil on canvas

MARC CHAGALL'S PAINTINGS,
many of which border on
fantasy, often have a symbolic
element, the meaning of which
only he could explain. Often,
too, the symbolic elements
reappear in other paintings.
The bird and the flowers in
this painting, which seem to
express joy and happiness,
reappear in other paintings,
especially Chagall's paintings
of lovers. Chagall's handling of
paint often appears very loose
and instinctive, but brings his
paintings together into the
whole creative concept which
is essential to all satisfying
paintings.

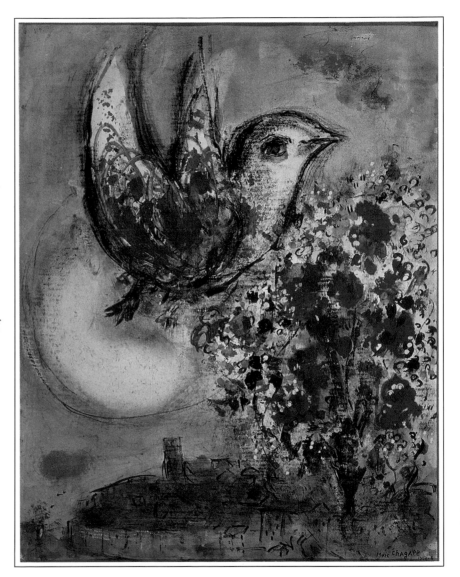

▷ **Baigneuses** 1910
Georges Rouault (1871-1958)
© ADAGP, Paris and DACS, London 1995

Oil on canvas

A DEEP RELIGIOUS FEELING pervades Georges Rouault's work, even when he is painting nudes and prostitutes. It is a feeling which sprang from his strong Catholic faith and his deep compassion for life and people. His early style was influenced by Gustave Moreau, who taught him at the Ecole des Beaux-Arts in Paris and who painted symbolic and fantasy paintings often with a religious connotation. Like Goya, he was a pessimist and rebelled against the cruelty and hypocrisy of the world in sombre paintings in which he outlined his figures in black – a relic, perhaps, of the time when he was an apprentice in a stained-glass window factory. The need to express directly what he felt made Rouault an Expressionist, like the Norwegian Munch, but without Munch's hysteria.

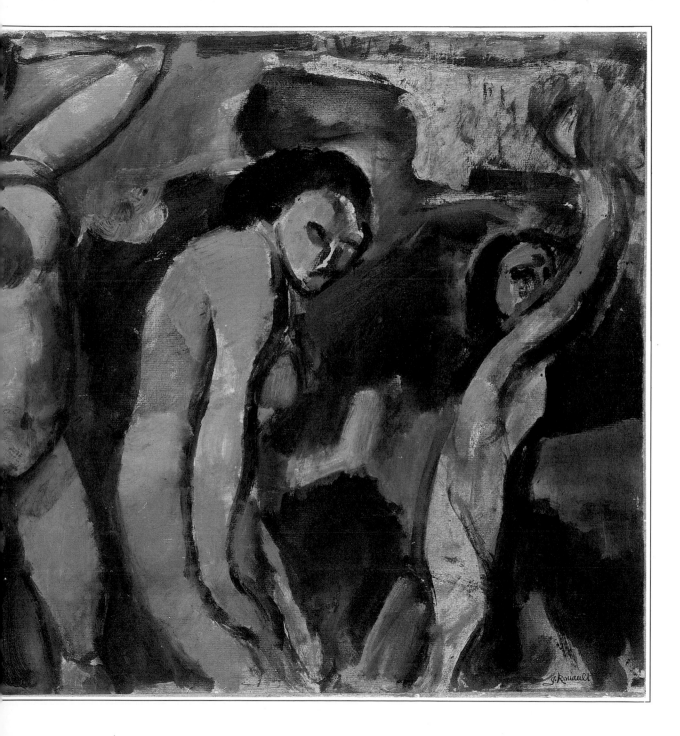

▷ **The Little Pastry Cook** c1925
Chaim Soutine (1894-1943)
© DACS 1995

Oil on canvas

CHAIM SOUTINE was a Russian who made his way to Paris before the outbreak of the First World War. Like Chagall, Soutine was imbued with a deeply Russian feeling for religion and folk life, which gave his work a powerful presence more significant than any theories on art. Van Gogh was the most important artistic influence on him. Like van Gogh, Soutine was uncomfortable with the middle-class bourgeoisie of his time and preferred the company of the poor and of prostitutes. The death of Modigliani, his companion in sorties into the low life of Paris, in 1920 so shocked him that he gave up drinking and became a teetotaller. This painting of a pastry cook is painted with the compassion he felt for the hard working and underprivileged, who supplied the needs of the rich in his time in Paris.

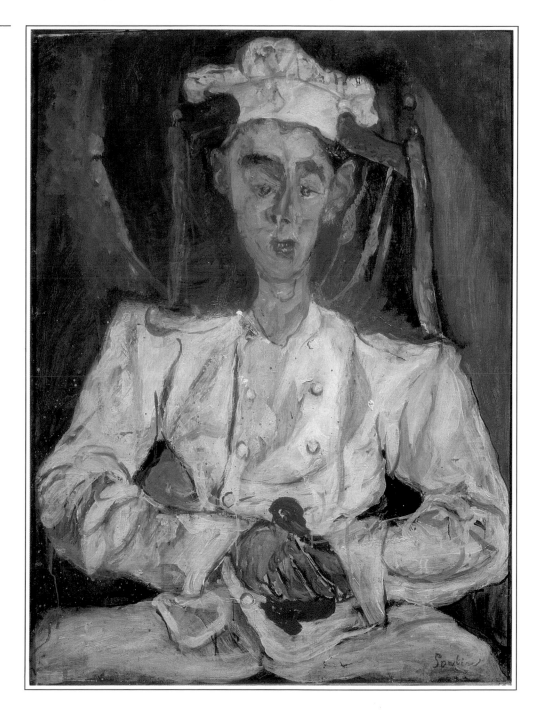

▷ **French Port, Dieppe** 1926
Sir Matthew Smith (1879-1959)

Oil on canvas

AT A TIME WHEN most English painters were pursuing generally conventional forms of art, Matthew Smith went to Paris in 1910, briefly attending a school run by Henri Matisse. He was immediately won over to the Fauve approach to painting which liberated in him the love of opulent forms and exotic colours which became characteristic of his work. His main subjects became nudes and flowers, both of them admirably suited to the Fauve technique. The combination of subject and technique did not appeal much to conservative, easily shocked English tastes, but Smith persisted to such effect that he was eventually given a knighthood. He also succeeded in winning over other painters and art-lovers in England, introducing to English artists a greater freedom in the handling of paint.

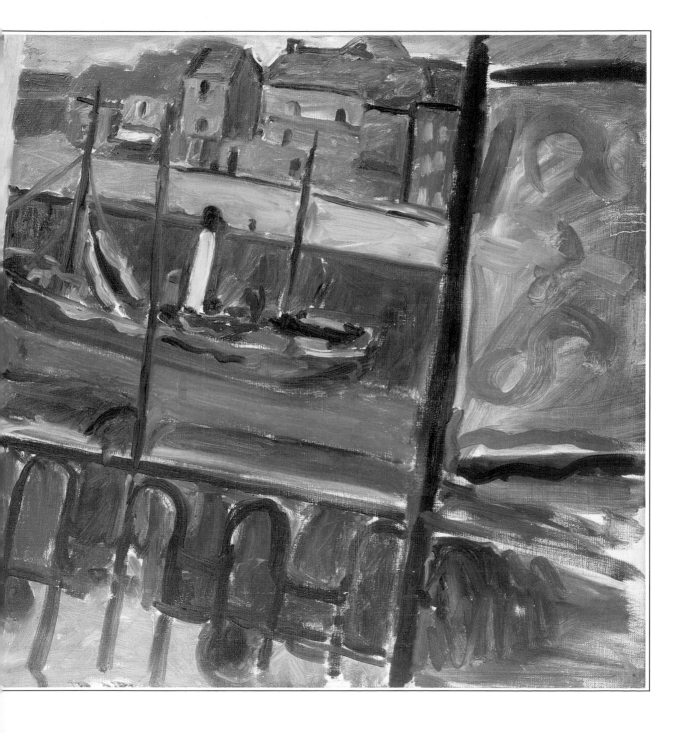

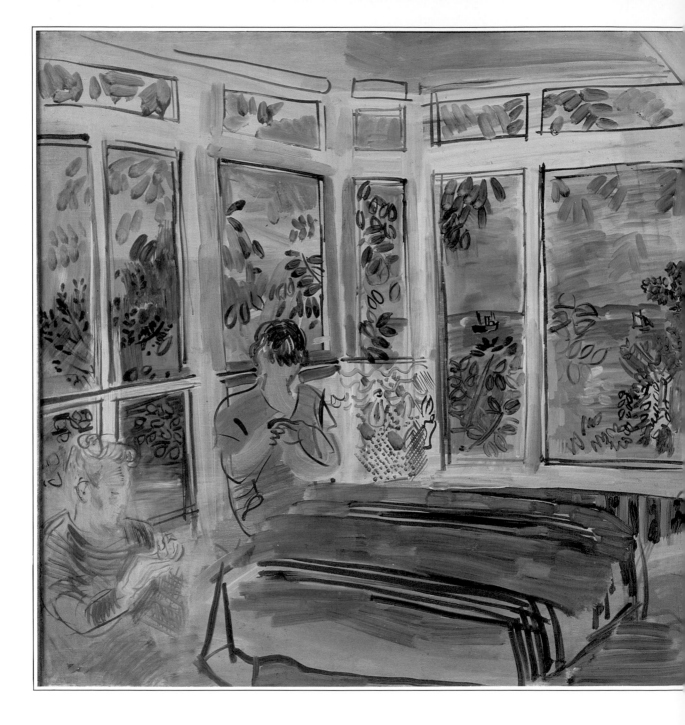

◁ **The Veranda at Villerville** c1930
Raoul Dufy (1877-1953)
© DACS 1995

Watercolour

FIRST ATTRACTED BY the Impressionists, Raoul Dufy was inspired by the Fauve painters, in particular Matisse's *Luxe, Calme et Volupté* to simplify his style. Since it was not in his nature to use extravagant colour, it was the Fauves's free handling of material that most impressed Dufy. The particular appeal of Matisse's painting may have been as much in the subject as the actual technique, for Dufy was attracted by the leisure life and his subjects were frequently casinos, race courses and fashionable resort promenades, which he depicted with bold splashes of colour. In this painting he expresses the light, airy veranda in a charming domestic scene.

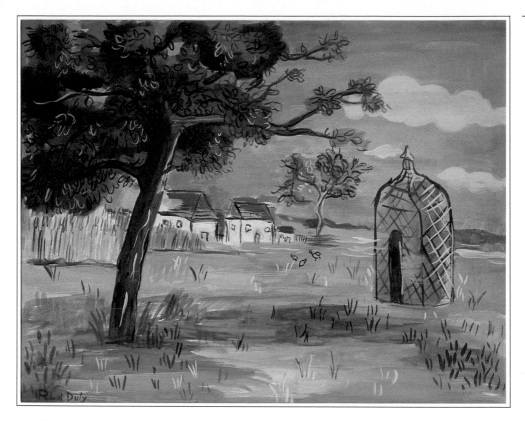

△ **The Summer House** c1930
Raoul Dufy
© DACS 1995

Gouache

RAOUL DUFY'S TECHNIQUE was one way of solving the age-old problem of finding a way of allowing drawing and colour to have equal value in a painting. By treating each as a separate means of expression, he allows both his colours and his calligraphic style of drawing free rein. Dufy was as successful a designer as a painter and his wallpaper and textile designs became extremely fashionable. In this painting of a rather lonely-looking summerhouse, the drawing is refreshingly childlike, but the choice of colours – green grass, purple sky with patches of yellow as contrast – is sophisticated.

▷ **Place de la Trinité, Paris**
1911
Albert Marquet (1875-1947)
© ADAGP, Paris and DACS,
London 1995

Oil on canvas

ALBERT MARQUET was a
painter, who, while profiting
from the experiments of
others, stayed within the
mainstream of tradition,
though adding his own
personality to it. An
unassuming and reflective
painter, he was easily accessible
to the public and won an
enduring place among the
Post-Impressionists. Though a
friend of Matisse and an
exhibiter at the original Fauve
exhibition of 1905, he did not
follow the Fauve direction in
the search for colour solutions
in painting but retained his
very personal style, excelling
in fine tonal relationships. In
this painting he is following
Pissarro, Renoir and Monet in
painting overhead views of the
entertaining streets and
squares of Paris.

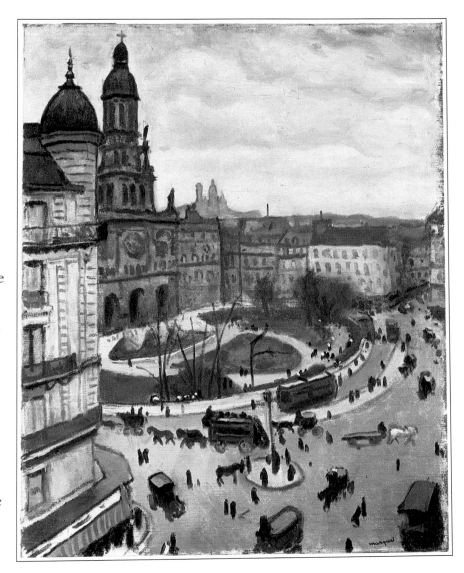

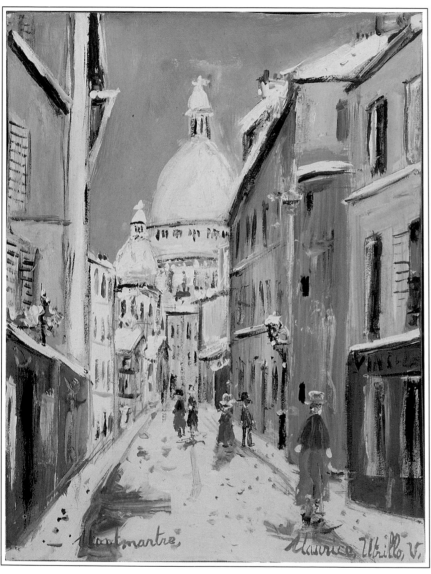

◁ **Sacré Coeur, Montmartre**
1934
Maurice Utrillo (1883-1955)

Gouache

MAURICE UTRILLO was the son of Suzanne Valadon, an artist's model and talented painter in her own right, and from early youth he moved among the Impressionist and post-Impressionist painters of Montmartre. He was drawn to the café and cabaret life and began to drink and to take drugs. His mother encouraged him to paint, hoping that this would give him another interest in life but his painting did not distract him from his vices. It did not help that he was a friend of Modigliani, another heavy drinker and drug addict. Unlike Modigliani's, Utrillo's painting was simple and direct, displaying an almost childlike reaction to his environment. His love of Montmartre is expressed admirably in his paintings, though many of them have a garish picture-postcard character. In this snow scene, Utrillo has captured well the atmosphere of the street looking up to the Place du Tertre and the Sacré Coeur church beyond.

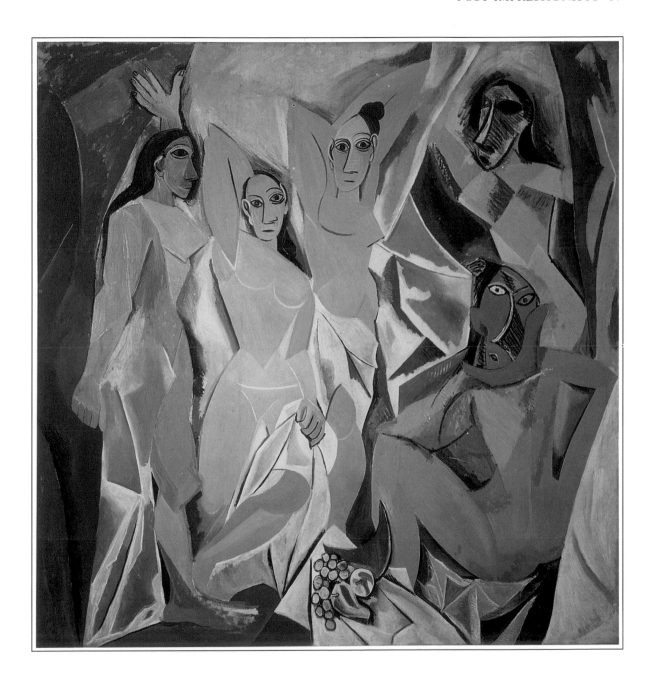

Les Demoiselles d'Avignon
1907
Pablo Picasso (1881-1973)
© DACS 1995

◁ *Previous page 67*

Oil on canvas

IN HIS LONG LIFETIME Pablo Picasso was involved in almost every form of art expression, including Realism, Impressionism, Divisionism, Surrealism and Cubism. This painting of prostitutes in a Barcelona brothel with its playful title grew out of Picasso's interest in African art, though the influence of Cézanne, who had developed a structural view of nature, is also clear. The figures on the left are clearly like African sculpture, while those on the right have the flat forms prevalent in post-Impressionist art. Picasso's break with existing art forms led to abstract forms of art and could be said to mark the end of the post-Impressionist experiments in progressing the ideas of Impressionism.

▷ **Château Roche** 1909
Georges Braque (1882-1963)
© ADAGP, Paris and DACS, London 1995

Oil on canvas

LA ROCHE GUYON, to the north of Paris, was a popular rendezvous for the Impressionists; in this painting, Georges Braque has interpreted the landscape in a Cubist manner. The structure of the hills, trees and castle has been analysed in terms of the planes, much as Cézanne might have done, but with less concern for the actual character of the subject. Before the First World War, Braque worked closely together with Picasso in the development of Cubism, but the two painters later grew apart, with Picasso going on to other ideas while Braque continued to refine the Cubist idea in complex still lifes.

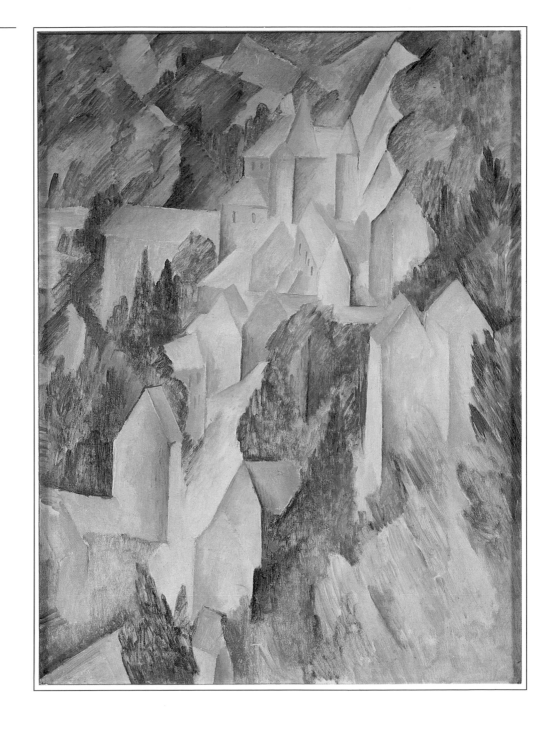

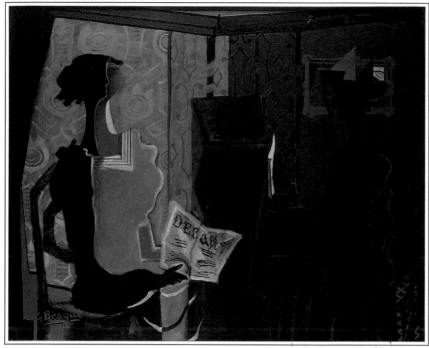

△ **Duet** 1937
Georges Braque (1882-1963)
© ADAGP, Paris and DACS, London 1995

Oil on canvas

IN THIS SPLENDIDLY VIGOROUS painting Braque has turned to a figure composition, with a woman playing the piano and another holding a piece of sheet music. Here, he has moved away from the almost abstract Cubism of his years of association with Picasso and is acknowledging reality with a sympathetic curving line to describe the figures, which are part of a harmonious composition of line and colour. This pursuit of colour and harmony became the theme of his later years, when he was asked to decorate the Etruscan Room at the Louvre.

▷ **Still Life with Violin and Guitar** 1913
Juan Gris (1887-1927)
© DACS 1995

Oil on canvas

GRIS WAS BORN in Madrid and went to Paris in 1906, where he lived in the artists' colony at Montmartre and became friends with Picasso, another Spaniard. He became a disciple of the Cubist idea and his early paintings followed the disciplines of all Cubist painters, analysing the structure of figures in ever finer detail. Later, however, he developed the flat cubism in which the planes were flattened in order to preserve the two-dimensional nature of the painting surface. This led to more flexibility in the manipulation of the forms, as in this still life with violin and guitar, where the musical instruments and the table become one unit bound together in a composition of great structural strength.

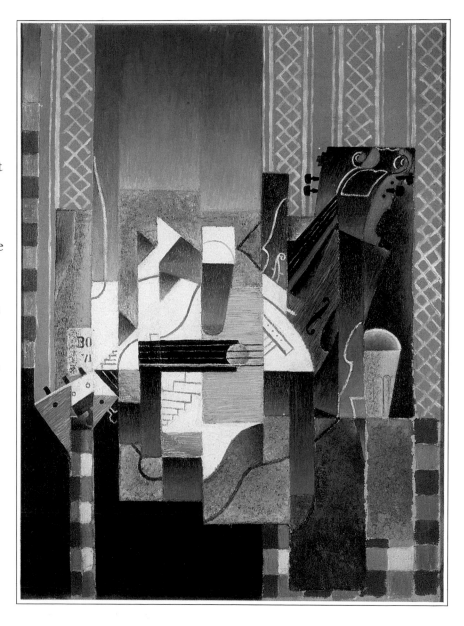

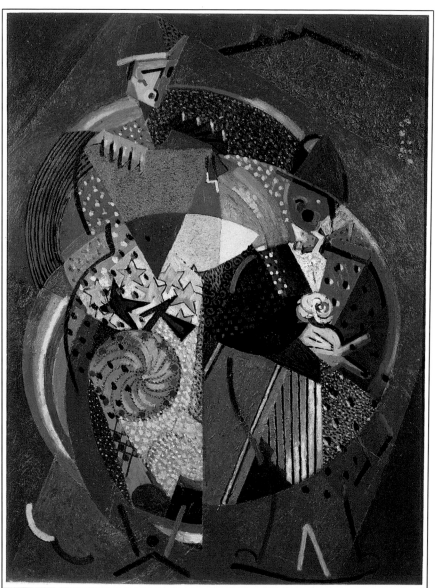

◁ **The Clowns** c1916
Albert Gleizes (1881-1953)
© ADAGP, Paris and DACS,
London 1995

Mixed media

ALBERT GLEIZES, who was
co-author with Jean Metzinger
of the first book on Cubism,
Du Cubisme, published in 1912,
was thoroughly convinced that
the new art theory was the
answer that artists had been
seeking since the birth of
Impressionism. He practised
the flat Cubism style. which in
this painting has been used in
a purely imaginary subject.
Flat Cubism, also called
analytical Cubism, lent itself
to collages or part collages
where some of the flat areas
were created by sticking pieces
of paper on the painting
surface. Though Cubism was
an art form which appealed
to rationalists, Gleizes, who
was a religious man, tried to
combine it with ideas from
Roman Catholicism.

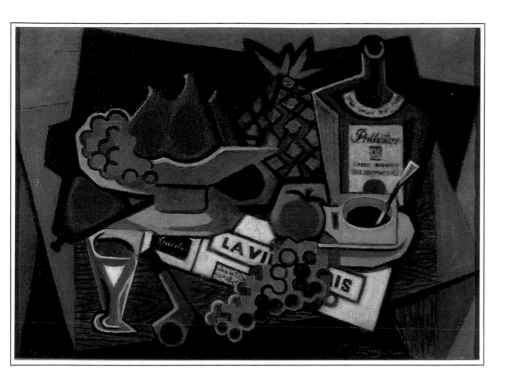

△ **Still Life with a Newspaper** c1920
Jean Metzinger
© ADAGP, Paris and DACS, London 1995

Oil

JEAN METZINGER was one of the pioneers of Cubism and co-author with Gleizes of the first book on Cubism. Though fully committed to the idea of Cubism, Metzinger's own work often betrays a liking for realistic drawing which appears among the severe angular planes of his Cubist compositions. In this painting he has stayed within the parameters of his schematic abstraction which, though it may look like Cubism, does not have the imaginative analysis and synthesis of that form of art.

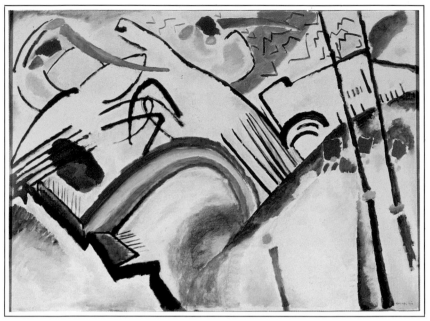

△ **Battle (Cossacks)** 1910
Wassily Kandinsky (1866-1944)
© ADAGP, Paris and DACS, London 1995

Oil on canvas

ABSTRACT ART, beginning with the dawn of the 20th century, opened up an entirely new field of exploration for artists by marking a watershed between Post-Impressionist art and the art of the present century. At first, abstract art was based on a figurative subject, but painters like Moscow-born Wassily Kandinsky carried it on to pure abstraction, though sometimes their paintings, such as this one, were given a theme title. Kandinsky studied in Munich and became a teacher at the famous Bauhaus, like Paul Klee. He wrote a book called *Spiritual Harmony* which helped his ideas to have a powerful effect among artists, especially in Germany where he was co-founder of the Blaue Reiter Group.

▷ **Sun and Moon** (subtitled **Starker Traum**) c1920
Paul Klee (1879-1940)
© DACS 1995

Oil on canvas

LIKE ODILON REDON, but in a completely different and personal manner, Paul Klee, who was Swiss, created a fantasy world bordering on the abstract, but with a strong emotional content. He trained in Munich and then went to Italy, later joining the influential Bauhaus as a teacher. His own influences were English, for he admired the work of William Blake and Aubrey Beardsley, but he was also attracted to Goya's drawings in such series as *Los Caprichos* and *Disasters of War.* Klee's very idiosyncratic work has often a touch of humour and his forms are based on real objects.

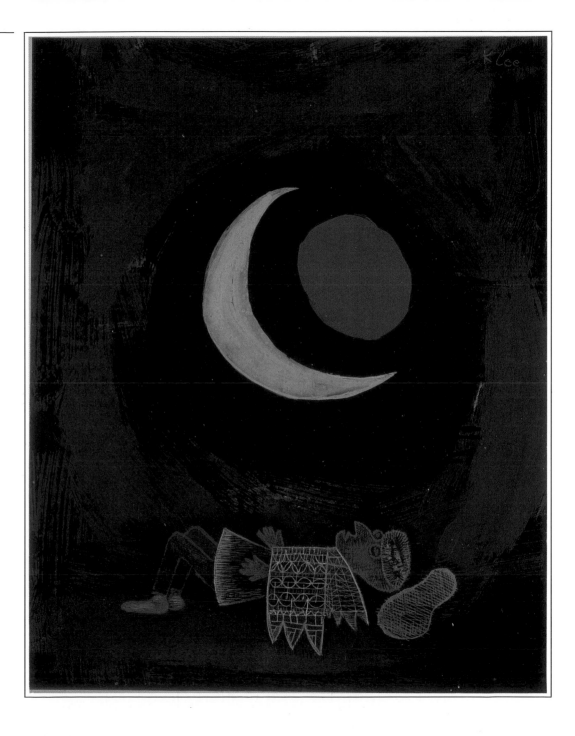

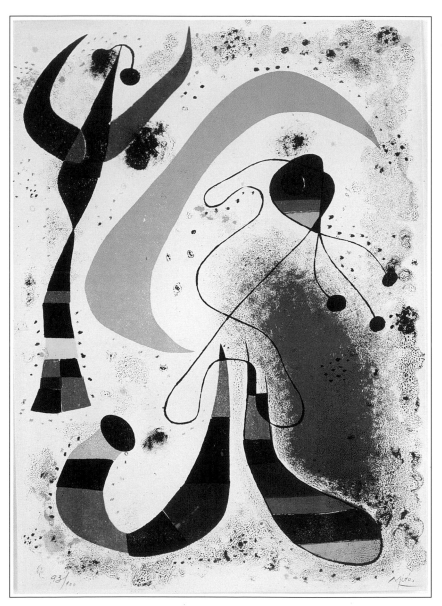

93/100

◁ **La Nuit**
Joan Miro (1893-1983)
© ADAGP, Paris and DACS,
London 1995

Lithograph

IN THIS EXAMPLE of his lithographic work, printed in an edition of 100 copies, Miro engages in more exploration of the possibilities of the technique than was found in *Figure Against a Red Sun* but is still using the familiar forms of his work at this time. Except for the possible indication of stars, the connection with night seems somewhat tenuous and the image relies largely on Miro's undoubted decorative pattern-making ability. Although, as has been noted, Miro was disturbed when he believed his work had become 'easy', the technique itself does often lack a structured tension, and in a considerable rise in his prices and, like most of his contemporaries, he made a number of limited editions in lithographic form. While the prints were sold relatively inexpensively in the first instance, they have now assumed the rarity of painted originals and are consequently collectors' items.

> **And Fix the Hairs of the Star**

Joan Miro (1893-1983)
© ADAGP, Paris and DACS, London 1995

Oil on canvas

THE SUBCONSCIOUS MIND of the artist which Surrealism had released was expressed in literature by automatic writing, in which an author put down everything that came into his head without conscious direction. The same principle was applied to painting by some artists like Klee and Joan Miro who, in this painting, has made the subject even more ambiguous by the title. Miro, who was a friend of Picasso and of Dali, both Spaniards, included work in the first Surrealist exhibition of 1925. Though sometimes thought of as an abstract painter, Miro claimed that his forms were real and not 'forms for forms sake'. He was also a gifted ceramicist and his work often shows a puckish sense of humour.

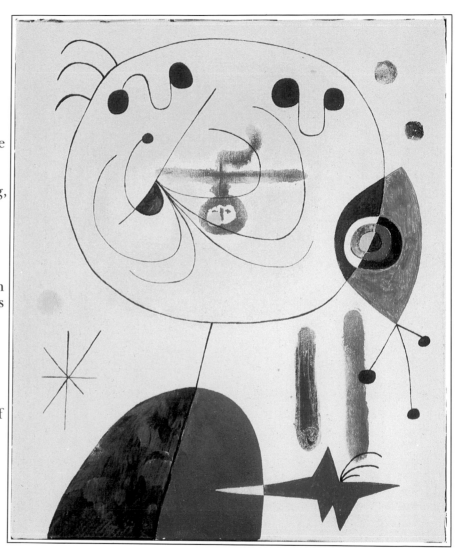

◁ **The Signs of Evening** 1926
René Magritte (1898-1967)
© ADAGP, Paris and DACS,
London 1995

Oil on canvas

THE END OF THE Post-
Impressionist period in art
came with the appearance of
Abstract Art and Surrealism.
The latter sprang from Art
Dada which set out to destroy
every trace of the art thinking
of the past, including
Impressionism and Post-
Impressionism, which was seen
as an extension of traditional
art. The Dadaists wanted to
start the process of art with a
clean slate. Surrealism aided
this process by ignoring the
conscious approach and
replacing it by processes that
lay deep in the unconscious
mind. The Belgian artist René
Magritte and the Spaniard,
Salvador Dali were the best
exponents of the kind of
Surrealism which created new
reactions out of unthought-of
combinations of real objects.

ACKNOWLEDGEMENTS

The Publisher would like to thank the following for their kind permission to reproduce the paintings in this book:

Bridgeman Art Library, London: /**Hermitage, St Petersburg:** Cover, Half-title, 8-9, 12-13, 20-21, 46, 65; /**Courtauld Instutute Galleries, University of London:** 10-11, 32-33; /**Museum of Modern Art, New York:** 14-15, 44-45, 67; /**Musee des Beaux-Arts, Chartres:** 16; /**Tate Gallery, London:** 17, 35, 50-51, 74; /**Musee d'Orsay, Paris/Lauros-Giraudon:** 18; /**Musee de l'Annonciade, Saint Tropez:** 19; /**Petit Palais, Geneva:** 22-23, 52-53; /**Albright-Knox Art Gallery, Buffalo, New York:** 24; /**Norton Gallery, Palm Beach:** 26-27; /**Private Collection:** 28, 72, 75, 77-78; /**Musee Toulouse-Lautrec, Albi:** 29, 36; /**Rijksmuseum Kroller-Muller, Otterlo:** 30; /**Christie's, London:** 31, 40-41, 54-57, 66; /**Roy Miles Gallery, 29 Bruton St., London:** 34; /**Williamstown Art Institute, Williamstown:** 37; /**Pushkin Museum, Moscow:** 38-39, 47, 76; /**Historisches Museum der Stadt, Vienna:** 42; /**Phillips Collection, Washington DC/ Giraudon:** 48 /**Musee des Beaux-Arts, Pau:** 49; /**Musee de l'Orangerie, Paris:** 59; /**Guildhall Art Library, Corporation of London:** 60-61; /**Musee des Beaux-Arts, Le Havre:** 62-63; /**Waterhouse & Dodd, London:** 64; /**Moderna Museet, Stockholm:** 69 /**Musee National d'Art Moderne, Paris:** 70; /**Prado, Madrid:** 71 /**Whitford & Hughes, London:** 73;